Other works by the same author:

Futurism: Art at the speed of life

Magia, genio, follia: Leonora Carrington

Per un'estetica della contraddizione: Julius Evola e il superamento del Dadaismo

Psicanalisi della pittura: Dino Valls e l'immagine attiva dell'inconscio.

In no way is it legal to reproduce, duplicate, or transmit any part of this document in either electronic means or in printed format. Recording of this publication is strictly prohibited, and any storage of this document is not allowed unless with written permission from the publisher. All rights reserved.
Copyright © Lucio Giuliodori 2018.
ISBN-10: 1076016138 ISBN-13: 978-1076016133
ASIN: B07K5MRP57
www.luciogiuliodori.net

Lucio Giuliodori

Metaphysics of silence: Giorgio De Chirico.

INDEX

1. Ferrara and the early twentieth century Italian context.

2. De Chirico and Surrealism

3. The ghost of reality: Metaphysical art.

4. Beyond humanity: statues and dummies

5. The influence of Nietzsche.

6. Migraine aura: a source of revelation.

7. Conclusion.

Art is the supreme task and the truly metaphysical activity in this life.

Friedrich Nietzsche

Omnia aliena sunt. Tempus tantum nostrum est.

Lucius Annaeus Seneca

Ferrara and the early twentieth century Italian context.

In the early twentieth century, the North of Italy began a slow process of industrialization that involved some new social phenomena, such as the emigration from the south of the peninsula and the formation of large urban agglomerations.
However, the modernization of the economy was not enough to solve the problems connected to employment and many Italians were forced to emigrate abroad. After the difficult period of the "great depression", which caused a serious economic crisis between 1873 and 1895, production began to grow again; the years between the nineteenth and twentieth centuries were characterized by an increase in welfare, especially for the bourgeoisie and, on top of that, the European states could enjoy a period of relative peace, the so called *Belle Époque* (which lasted from 1890 to 1914).
In these years the department stores were born, and with them advertising too, the *caffé concerto* - bars where you could drink listening

to music - spread and world' fairs were set up where the best industrial and handicraft production were put on display. People started to have *free time* and places where they could enjoy it, flourished. The streets of the cities were full of colors: billboards, shop windows with all kinds of goods, elegant warehouses. That, of course, not only affected people's mentality and their new carefree way of dealing with life but it also had affected the productive sectors. Among the consequences, a series of artistic currents, that theorized that every human production could become an artistic expression, had developed. According to this new way of thinking, every object and every place became an elegant decoration, a floral motif, a curved, arabesque line. In such social context, a new artistic trend was born, the *Liberty* or *Art Nouveau* , which was expressed above all through the figurative arts and home furnishings. Moreover, two new kinds of art appeared, and they would have had great importance in the following decades: cinema and comics.

This was the society where Giorgio De Chirico started to take his first steps. He was born in 1888 in Volos, Greece, to a Genovese mother

and a Sicilian father. His father Evaristo, was an engineer working for the railways.

He returned to Italy in the summer of 1909 but after just two years he moved to Paris, however, at the outbreak of World War One, he came back to Italy. Here, in Ferrara, at the "Military Hospital for war neurosis", in May 1915, he met with Carlo Carrà, they both were soldiers, they both were painters and they both were hospital residents at that time. That encounter was extremely fruitful for Italian art as, the *Pittura metafisica* movement was founded just as a result of that coincidence. As faith would have it, an art movement which investigates the enigmas of (the psyche perceiving the) reality was born just in such a hospital - which De Chirico used to call "villa of enigmas". That was one of the fundamental episodes of twentieth-century artistic history, destined to change the development of art, not only Italian but European as well. It is just in those rooms that De Chirico and Carrà painted some of their most famous works such as *The disquieting muses, Hector and Andromache, Trobadour, Solitude, The enchanted chamber, Mother and son, The metaphysical muse.*

Moreover, not just the villa with its psychiatrics and mental patients walking

around was inspiring but the city of Ferrara itself was. The latter represented a very significant place as its surroundings deeply influenced De Chirico's art, where monuments, squares and buildings were predominant subjects. De Chirico, in his *Memories*, defined Ferrara as "one of the most beautiful and enigmatic cities of Italy"[1].

After 1918, De Chirico was already a famous name and his work was exhibited extensively in Europe. However, the most important period of De Chirico's production was definitely between 1909 and 1919, the metaphysical period indeed, where mannequins-like hybrid figures and eerie empty squares at broad daylight, were the main topics.

[1] From the documentary *Giorgio De Chirico a Ferrara, la nascita della metafisica*, in: https://www.youtube.com/watch?v=hUHZB2vFDDE&t=325s

I found that I could say things with color and shapes that I had no words for.

Georgia O'Keefe

De Chirico and Surrealism

Amid De Chirico and surrealists, relations didn't last long. The Master and Breton, after an initial mutual appreciation, ended up insulting each other. A strong kinship with the movement itself, however, never ceased, and the unquestionable indebtedness of some of the greatest surrealists - let us mention Dalì, Ernst and Magritte, just to name a few – confirms it.

As we will shortly see, the distance is first and foremost conceptual: Surrealism never fascinated De Chirico's concerns and he never ended up under the spell of it.

However, we can't fail to identify a "surreal" tone in many of his works. *The return of Ulysses* for example, a clearly autobiographical painting in which Ulysses plows the sea into a room, is clearly oneiric.

A colossal oneiric atmosphere embodies and substantiates many other De Chirico's works too, where the use of juxtaposition is typically surrealist, let us mention *Square*, *Strange travelers*, *The disquieting muses*, *The enigma of skyscrapers*, *Furniture and rocks in a room* , and

basically all the *Metaphysical interiors*, all the *Bathers*, all the *Mannequins* and all the *Archeologists*.

However, the main difference is the following: while surrealists, under the strong influence of Freud, were mostly focused on deciphering dreams and the mysteries of the unconscious – let us remind ourselves of Breton's famous statement "the vigil is an interference" – De Chirico was struck by lights, shadows, squares, buildings, monuments, *things* that surrounded him in his everyday life. If surrealists were interested on what dwelled within, De Chirico was totally concerned about the perceivable world: too easy to spot an enigma in the world of dreams, even banal, much more intriguing, on a philosophical level, is trying to depict it on the things we look at with our own eyes.

As he points out: "In dreams, strange it may seem, no image would strike us, no image holds metaphysical power"[2], conversely much stranger and intriguing is "how certain things

[2] G. DE CHIRICO, *Sull'arte metafisica*, in *Commedia dell'arte italiana*, Milano: Abscondita 2002, p. 26. My translation.

From now on, for all the Italian books quoted, the translations from Italian into English are mine.

and certain aspects of life appear to our mind"³.

> "De Chirico never painted dreams nor did he exactly attempt to express the world of the unconscious in his paintings. It is certain that he aimed to get closer "to the dreams and openness of the spirits of children", in order to strip objects of their burden of meaning. It is often said that De Chirico painted phantom cities, when what he really did was reduce the spaces and objects that he painted to the condition of phantoms. It is this detachment that converts his images into disturbing, even sinister omens: breaking up the relationship of meaning among objects"⁴.

De Chirico claims that in the shadow of a man walking in the sun there are more enigmas than in all the religions of the world. That is why his metaphysical painting has emptied people's squares and filled them with shadows. In De Chirico, shadows are crucial and represent a reflex of being itself, in this respect his art holds a declination in the key of

³ *Ibidem.*
⁴ J. M. FAERNA, *De Chirico*, New York: Cameo/Abrams 1995, p. 6.

ontology, just because of the importance he gives to the category of being, meaning what exists out there, what we do see and experience empirically. René Magritte, who was utterly struck by De Chirico's art, shared the same metaphysical perspective: according to him the enigma that should have been talked about and that could have been perceived by the mind, "is that of the World, of the Universe, and not the one of a greater or lesser esoteric author"[5]. It is about "that being that never offers itself for what it really is, or rather, whose offering in the silence of the world is its same and precise manifesting as an enigma"[6] as Massimo Donà beautifully puts it in *Arte e filosofia*.

He didn't need to delve deeper into the mysterious meanders of the unconscious, the everyday life with its lights and objects, was mysterious enough, at least for a philosophical investigation.

A world on the brink is what he displayed and he, himself, lived right there, compelled between those eerie buildings and empty squares, made of silence and wonder.

[5] R. MAGRITTE, *La combinazione della mia arte*, Abscondita: Milano 2003, p. 47.

[6] M. DONA', *Arte e filosofia*, Milano: Bompiani 2007, pag. 317.

It is not by looking at things that we understand them, but by dwelling in them.

Wendy Wheeler

The ghost of reality: Metaphysical art.

In a letter to Guillaume Apollinaire, in 1814, he writes:

> "I will bring *The Enigma of a Day* to you one of the next few days. I thought of a title for Miss Laurencin's painting today *Mystery of a Moment*, because the various things represented in it appear with the same suddenness that occurs at certain times when the intimate essence of objects appear to us in their full metaphysical reality"[7].

Even though the word "metaphysics" outlines what goes beyond physics, i.e. a transcendent dimension that can't be experienced by the five senses, De Chirico's use of the term, as by now we can guess, was totally devoid of "spiritual" implications. He didn't set metaphysics beyond physics but rather in physics, deep into the hidden core of it. A Latin inscription in one of his self-portraits elucidates this: *Et quid amabo nisi quod rerum*

[7] *Letters from Giorgio De Chirico to Guillaume Apollinaire. Paris – Ferrara 1914 - 1916*, in http://www.fondazionedechirico.org/wp-content/uploads/611-622Metafisica7_8.pdf

metaphysica est? (what I will love if not the metaphysics of things?).
Consequently, the paintings' aim is not restricted to a loyal reproduction or banal imitation of things, rather it aspires to unveil the secret spirit of things, their quintessence concealed behind the surface accessible to us through the senses. To this regard his art is utterly philosophical and the painter, to his credit, is assigned a new noble task.
As Franco Calarota puts it:

> "De Chirico starts from the physics of real phenomena connected with the five senses in order to go beyond everything previously achieved, both by those before him and by himself, to transcend phenomenal reality and reveal what lies above: the absolute, the essence, the truth of everything"[8].

His masterpieces usher in this new attitude which strikes as it offers a glimpse into rarefied landscapes which belong to another (parallel) reality. His pictures are investigations of the unknown, they don't describe, they *inquire* and by doing this they

[8] F. CALAROTA, *Giorgio De Chirico and the Divinatory Instinct*, in *Giorgio De Chirico: myth and archeology*, Milano: Silvana Editoriale 2013, p. 20.

floor us as they dwell on that mysterious, yet familiar limbo sited between ordinary and extraordinary reality, logic and absurd, physics and *metaphysics*. De Chirico's empty and mysterious cityscapes pierced by the bright daylight out of time, revived only by shadows, statues and mannequin-like hybrid figures, perfectly depicts his *philosophy*: a heartfelt attempt to transcend the human realm, humanity has no interest whatsoever, rather what overcomes it matters as it implies something yet to be acknowledged.
In his own words:

> "In order for a work of art to be truly eternal, it must transcend the boundaries of humanity. Good common sense and logical thinking do not apply. The artist must bring forth a truly deep work from the most remote depths of his being. There no rushing rivers, no birdsong, and no rustling leaves can reach"[9].

Even more precisely, the goal of *Pittura Metafisica*, according to the Master, was "to construct a new metaphysical psychology through painting"[10] – a very impressive

[9] Quoted in D. EIMERT, *Art of the 20th Century*, New York: Parkstone 2013, p. 103

mission indeed. He makes it even clearer by stating:

> "Almost everything has two aspects: There is the normal aspect that we almost always see, then there is the ghostly, metaphysical one that rare individuals might see in moments of clairvoyance and metaphysical abstraction"[11].

It seems to hear the echo of Carlos Castaneda, when he will state a few decades later: "There are not two separate worlds, two different realities, a normal world and a paranormal world… but only one world, that you can *look at* or *see*".

De Chirico keeps clarifying:

> "A work of art must speak poetically about something that is far away from the figures and objects, as well as what its material shapes conceals them from us"[12].

De Chirico uses a beautiful expression to describe the aims of Metaphysical Art: "look at the world as if it were the first time", in order to achieve this goal, a sort of alchemical

[10] *Ibidem.*
[11] *Ibidem.*
[12] *Ibidem.*

operation is required: trying to erase all memories from one's mind, so that the objects of the world would reach a kind of purity and uniqueness, never seen before.

Faerna explains:

> The term "metaphysical" represented to De Chirico a search for the essential meaning hidden behind the surface of objects. He believed that objects acquire various meanings when imbued with the memory of their viewer. If that which de Chirico called the "chain of memories" is broken, the object acquire a new and disquieting guise, a "ghostly and metaphysical aspect that only a few individuals can see in moments of clairvoyance and metaphysical abstraction".[13]

Painting then turns out to be an initiatory way and the painter himself a "clairvoyant", using his own language, basically an initiate through and through. As De Chirico points out: "In silent life" – silence is crucial in De Chirico, almost all his work speaks of silence, emanate silence – "one must listen, understand, and learn to express the faraway voice of things... that invites us to come in

[13] J. M. FAERNA, op. cit. p. 14.

touch with them behind the inexorable screen of matter"[14].

It's all pretty straightforward now: the artist, through silence, i.e. a kind of "meditation", manages to speak with the things, he establishes an almost animist relationship with what surrounds him, he gets in touch with reality on a subtle level. Art then, is given an esoteric task *tout court*. As Renato Miracco outlines:

> "Merleau-Ponty suggested in his essay *The Eye and the Mind* that the painter gives visible existence to what vision believed to be invisible, and introduces us into a new experience where seeing is touching and being touched"[15].

De Chirico's squares then, are "mystic places" where he can mingle with things, dwelling on their oneness and be one with them.

Beyond "the inexorable screen of matter" the artist cannot find anything but the uniqueness of things, seen for the first time. And when things are seen for the first time, wonder

[14] Quoted in R MIRACCO, *The faraway voice of things*, in *Giorgio De Chirico: Myth and archeology*, op. cit., p. 15."Silent life" is also the word he coined to indicate a still life.

[15] *Ibidem*.

spreads and silence replaces words, just as shadows replaces men:

> "An oppressive silence prevails in the painting of De Chirico. Empty squares, streets without people – there are no living beings, no vegetation, only decoration. The figures appear artificial and unreal, as do the architectural elements; a faceless anonymity reigns in the paintings. The figures and architectural elements are artificially extended in higher or length and have enormous shadows. The monumentality of the decorations appears to extend into the infinite. All elements are bound into an overdrawn and overextended central perspective, into a reference system that seems to be directed an unseen force secretly at work. It is a metaphysical painting style bordering the unconscious, where the outsized becomes real, what in daily life is not possible becomes possible"[16].

Riddles, mysteries, shadows and enigmas are part and parcel of De Chirico's world, a world well-nigh invisible, stripped of its apparent

[16] D. EIMERT, *Art of the 20th Century*, op. cit. p. 103.

meaning, the one taken for granted, unquestionable as visible[17].

This is the way he calls the world into question, a very sophisticated way indeed.

He once stated: "There are more puzzles in the shadow of a man walking under the sun than in all past, present, and future religions"[18]. This sentence posits his approach in the extreme: not the man himself, who stands only as an obvious entity, but rather his stunning enigmatic shadow - abetted by his unattainable quintessence.[19]

He basically managed to spot the mysterious aspect of everyday reality giving to common

[17] However, in the last chapter we will see how his *gaze* is also profoundly influenced by one of his diseases: migraine aura.

[18] *Manoscritto 4*, Archivi della Fondazione Giorgio e Isa De Chirico, 1913.

[19] Here he reminds me of Pavel Florensky who during his childhood used to wonder in front of unsettling mysteries perceived in every nook and cranny, shadows and secrecies were always lurking around in his way.

To deepen this matter, see my article: *Esoteric elements in Pavel Florensky's philosophy* in Proceedings of the Conference *The garden of forking paths. Florensky, Rozanov, Durlyn et cetera*, Russian University for the Humanities RGGU, Moscow, 5-6 May, 2017. https://www.academia.edu/32875063/Esoteric_elements_on_Pavel_Florenskys_philosophy

objects "the dignity of the unknown". Again, the unknown *and* a compelling *metaphysical* reality worth being investigated, through art of course, as first and foremost the only aim of art is knowledge of ideas, as Schopenhauer stated[20].

Not human entities *tout court*, rather what exceeds them: a sort of beyond-beings as we've already seen, inspired by ancient and mythological characters, another persistent element in his art (again a blatant nietzschean influence)[21]. Space is often well-nigh empty

[20] "[Art] repeats or reproduces the eternal Ideas grasped through pure contemplation, the essential and abiding in all the phenomena of the world; and according to what the material is in which it reproduces, it is sculpture or painting, poetry or music. It's one source is the knowledge of ideas; it's one aim the communication of this knowledge". A. SCHOPENHAUER, *The world as will and representation*, New York: Dover Publications 1966, pag. 567.

[21] However, the subject's dismemberment is typical of the Avant-gardes, as Luigi Musacchio underlines: "In classical painting, Impressionism included, the subject of the paintings is clear, a talking character, ultra-present, an undisputed and unmistakable gentleman of the backgrounds laid out on the most varied supports (canvas, table, fresco). In the avant-gardes, the subject is dismembered in the cubism of Picasso, dematerialized in the constructivism of Mondrian, disappears in the abstraction of Pollock, in the supremacism of Malevic is nullifying - and it seems

because once we've gotten rid of humans and we are meditating about what comes next – the mannequins are works in progress – we stand lonely and silent.

Space is strictly connected with time: if space is emptied, time is immobilized. What's left is a deafening and puzzling silence which pervades any single corner of a distorted world, mirrored in De Chirico's *inneres auge*, laden of visions, filled with meanings. All is clear from the artist's perspective, nothing is misplaced, everything is where it should be and everything is marvellously compelling, worth being depicted. However, everything is clear, or rather *visible*, *only* from the artist's high perspective.

De Chirico never got on with his critics - unable in his eyes, to grasp his art – and here, by criticizing their sloppy and shoddy attitude towards his paintings, he unveils some little secrets necessary to approach his art:

forever. In De Chirico the subject returns but in his own way: having become the ghost of himself, he is no longer clear, he does not speak, he has become a character in search of an author to whom each observer can give his name: Oneiric? Enigmatic? Allusive? Mysterious? Or - more generically - Metaphysical?" L. MUSACCHIO, *Giorgio De Chirico, il pittore che sussurrava all'enigma*, News – Art, accessed 29/09/2018.

"This may be beyond comprehension, but that is the way I am. And if many people do not understand it is not my fault; it is the fault of frivolous, superficial men who do not know how to look inside my work. They do not know that in order to grasp certain mysteries, one has to reverse the position; frontal attack is of no use, it is a waste of energy. They do not know that in order to understand a vast and exceptional creation it is necessary to search behind the work; never focus on the surface in the hope of entering deeper, but begin from the wings, from the back, in order to reach the surface and the forestage"[22].

Again this classic esoteric narrative, typified by nietzschean influences, an elitist conception of art and knowledge which in such an artist reaches its peak: he seems to say that insofar as he is the main representative of the kind of art he himself conceived, he owns every reason to claim the exact interpretation of it.

The critic is supposed to be a viewer who inhabits an alternative space, far away from that of the artist, a position the artist should

[22] G. DE CHIRICO, *Why I illustrated the Apocalypse*, Milano: Edizioni della Chimera 1941, p. 27.

never reach, only because it doesn't pertain to him, to the same extent as air doesn't belong to the world of fish for example. This rule doesn't apply in De Chirico's conception of art, a neutral critical position for a possible viewer doesn't occur as he, himself, dwells in all the given positions at the same time. Space and time are relative categories in Metaphysical Art as the Master wipes them out replacing them with his same figure, which, like a supreme king-magician, permeates any meander of all the (infinite) space-time of his own output. He affirms:

> "The artist is allowed to "move", to escape to certain points" – let us ponder the verbs *to move* and *to escape*, crucial in this narrative – "that the good or evil rays irradiated form the (supposedly) unknown world to the (supposedly) known world, and vice versa, arrive with "differences" that the best thinkers are unable to explain, mattered little to me.
> As I have already said, the artist is allowed to "move". From point A, which represents the known world and from point B, which represents the unknown world, […] running between these two points, I change my position completely, and […] I go and situate myself at a third point C. From this point, finding myself in the safety zone of

"relativity", I enjoy the pleasure of the observer, the viewer and the creator"[23].

[23] G. DE CHIRICO, *Why I illustrated the Apocalypse*, op. cit. p. 65.

*I walked around the block twice, passed 200 people
and failed to see a human being.*

Charles Bukowski

Beyond humanity: statues and dummies

De Chirico was a sculptor as well and even though sculpture was not his preeminent commitment, this output was well entwined with painting.
Statues carve out quite a remarkable role as they personify "the metaphysical counterpart, the archetypal foundation that undertakes to represent painting in its primal emblematic quality and conceptuality"[24]. This is because statues take on a new appearance, as the Master himself states:

> "The statue erected on a building or temple, in the middle of a park or square, appears in different metaphysical guises. On the top of a building, standing out in detachment against a southern sky, it has certain Homeric quality, a sort of stern joyfulness steeped in melancholy"[25].

[24] G. DALLA CHIESA, *De Chirico scultore*, Milano: Giorgio Mondadori e Associati 1988, p. 20.
[25] G. DE CHIRICO, *Statues, Meubles, Généraux*, in *Bullettin de l'Effort Moderne*, pag. 27, in G. DE CHIRICO, *Il meccanismo del pensiero*, Torino: Einaudi 1985.

However, in order to transcend the human realm De Chirico uses another character, even conceptually stronger than the statues, the dummy:

> "A further metaphysical shift thus gradually takes place toward the *above* and *beyond*, and the sculpture loses its classical features in order to display its symbolic essence, being replaced by a dummy in a transformation made evident by explicitly referential titles like *Penelope and Telemachus* and *Hector and Andromache*. This transformation takes place in phases. Initially constituting an authentic counterpart of the statue, the dummy then exhibits features halfway between a marionette and a fencer before the final transformation in the "disquieting muses" that are simulacra of the De Chirico's metaphysical world"[26].

The Master's own words come to our aid:

> "As regards the dummy, the more human it looks, the colder and more unpleasant it becomes. The pathetic and lyrical character of my dummies, especially the seated ones in paintings like *The Archaeologists*, derives

[26] F. CALAROTA, *Giorgio De Chirico and the Divinatory Instinct,* op. cit. pag. 21.

> from their distance from humanity. The dummy is indeed disagreeable to our eyes because it is a sort of parody of a human being. It becomes an object with features close to human but devoid of movement and life. The dummy is deeply lifeless, and this luck of life disgusts us and make us hate it [...] Only those who take the time to observe a statue or a dummy carefully can realize that the dummy wants to be a man and is monstrous for this very reason. It aspires to life but is deeply lifeless, unlike a statue, which strives to be a work of art. A statue does not aspire to life but to the spirituality through which it attains immortality, the life of art"[27].

Thus, the whole picture is very clear now, on the one hand the statue and its thirst for immortality, on the other hand the dummy and its thirst for humanity. The first, the statue, holds good chances to achieve its goal, especially when it's made by a famous artist, already a work of art indeed, therefore already immortal. Conversely, the dummy is condemned to live a nonlife, inhabiting a

[27] G. DE CHIRICO, *Discorso allo spettacolo teatrale*, in «L'Illustrazione Italiana», Milano, 25 ottobre 1942. In *Scritti/1* pp. 506-517.

limbo which doesn't belong to anything or anyone.

However - here the genius of De Chirico hits the mark again - what about the dummies that he transforms into statues? To which limbo do they belong? Which is their reality? As a matter of fact, they stand for one more hybrid character in the already very crowded "De Chirichian family": they are something in the middle, the hybrid *par excellence* in the Master's art. However, as fully-fledged statues they succeed in attaining immortality, they take on metaphysical characteristics which allow them to fulfil the purpose of a work of art.

It is essential to stress the great role sculpture has in De Chirico's metaphysics, even a *divinatory* role, as the Pictor Optimus himself states:

> "The sculptor is the creator par excellence (…) he digs in order to bring forth (…). He begins to delve with divinatory instinct and what already lies with-in – the wonder, the divine toy that will provide the purest joy and lofty entertainment for him and for other human beings, his brothers and sisters – begins to raise the surface, to stir and move like a marmot awakening after a long sleep. And the good sculptor will achieve

> this through cutting, removing, digging, gouging, piercing, peeling, scraping and scratching"[28].

In conclusion we must consider that most of the sculptures of De Chirico are indeed mannequins, and almost all De Chirico's mannequins carry the artist's tool, such as the easels or the frames, this is because the artist identifies with them.

Mannequins are the Master's alter ego: they are devoid of eyes and mouths as they see the world with a kind of "third", inner eye, obviously more powerful than the human one; furthermore they are lacking a mouth as they don't need to speak, at least in everyone's language. The absence of the mouth symbolizes what in De Chirico is predominant: silence. They speak silence because the world they inhabit is a silent, mute world and in order to describe that world they don't need to speak whatsoever, they think though. The bulky geometrical constructions which they always bear, relate to a noetic architecture, an endeavour on the level of thought.

[28] G. DE CHIRICO, *Brevis pro plastica oratio*, in *Aria d'Italia*, 1940, in G. DE CHIRICO, *Il meccanismo del pensiero*, ed. by Maurizio Fagiolo, Torino: Einaudi 1985.

His brother Savinio, with his novel *Chants de mi mort* whose main character was a faceless man, deeply inspired De Chirico who starting from 1917 started to constantly paint mannequins.

However behind this choice, we cannot **not** spot, again, a blatant nietzschean echo: the dummies, *de facto*, replacing human beings, symbolize an attempt to overcome humanity, a work in progress towards the *Übermensch*.

The latter, considering De Chirico's love for Nietzsche is even a trite interpretation, that is why I do think one more layer of meaning could be spotted.

We should bear in mind De Chirico was a soldier, as such he experienced the brutality of war, he suffered the consequences of it, precisely at the Hospital of Ferrara, the "Villa of enigmas". Therefore the dummy, could also symbolize man facing something bigger than him, out of his control: war indeed. This man is physically and psychologically harmed, helpless and powerless, at the mercy of events. Such a man is in the throes of a kind of dehumanizing effect, in so far as he is living in a world ruled by madness, rather than rationality.

This interpretation is abetted by the famous work *Hector and Andromache*, where a soldier,

a dummy, is hugging his beloved woman as he is about to leave her, setting off for war. As we know, De Chirico grabs the Greek myths with both hands, and in Homer's *Iliad*, Hector is forced to leave his beloved Andromache, going off to war.

Classics are one of the clues to understanding the present, in De Chirico's art.

As Magdalena Holzhey highlights:

> "De Chirico developed the motif of the mannequin in conjunction with Apollinaire and Savinio. The human substitute without face or voice is blind like the seers of antiquity and equally gifted with the power of prophecy. The mannequin is the alter ego of the artist: the blackboard records stations along De Chirico's artistic journey"[29].

In conclusion, the mannequin, represents the achieved figure of his personality as it

> "becomes a modern formulation of the blind seer of antiquity, a figure with visionary powers. At the same time, it offers a graphic analogy with the increasing loneliness and alienation of modern man, the dissonance of human existence"[30].

[29] M. HOLZHEY, *De Chirico*, Köln: Taschen 2017, p. 40.
[30] *Ibidem*, p. 45.

Moreover, as Gerard Legrand points out to us,

> "Cabalistic tracery occasionally appears on manuscripts, and the mannequins display on their foreheads strange circular stigmata (presumably derived from the conventional sign for infinity), endowing these earless, eyelidless beings with such features as fish gills, or the single eye of the ancient Cyclops"[31].

[31] G. LEGRAND, *Giorgio de Chirico*, New York: Filipacchi Books 1979, p. 47.

La vera forza di un quadro è quella di restituirci un'assenza.

Manlio Sgalambro.

The influence of Nietzsche

Shortly after his father died, his mom Gemma decided to move to Germany looking at this country as an ideal place for her children's education. Her move, turned out to be totally farsighted.

In 1906, at the age of 18, Giorgio De Chirico entered the Academy of Fine arts in Munich. This was indeed an important chapter of his life in terms of his cultural education and his future *Weltanschauung*. From now on, De Chirico started to soak up the intense artistic atmosphere of one of the most vibrant European capitals at his time. The process of cultural assimilation affected not only the artistic sphere - his early works are deeply influenced by Böcklin, let us think of *The enigma of the Oracle* (1909)[32].

[32] "The pensive figure wrapped in a long cloak seen in a rear view, fully in the Romantic tradition of contemplative figures seen from behind" – let us think of Caspar Friedrich's *Wanderer* – "is cited almost literally from Böcklin's *Odysseus and Calypso* of 1882. De Chirico was fascinated during this period by Homer's account of the wanderings of the Greek hero Odysseus, who, as the embodiment of a traveler with an uncertain destiny, became another figure of identification in his

Nietzsche and Schopenhaur soon became strong pillars of his picture of the world, a world painted *with* their enthralling philosophies.

> "This distinctive grounding was markedly different from that received by most other young French and Italian artists of the period, whose lessons came largely from the poetic Tradition of Romanticism – Charles Baudelaire, Arthur Rimbaud and Stéphane Mallarmé. This difference helps to explain the singularity of De Chirico's work, which his contemporaries did not always understand. It also provides a clue to his method of painting, which was first intellectual and the pictorial"[33].

First of all, De Chirico shares with Nietzsche the love for ancient Greece and this is not only because he was born in that country. In the early twentieth century among artists and men of culture the love for classics, Greek

own life history. Böcklin's pensive Ulysses, yearning for home, becomes in De Chirico's painting a thinker contemplating the enigmas of the world and the mystery of his own existence. The oracle, voice of fate, is present in the shape of the marble head of a statue concealed behind a curtain". M. HOLZHEY, op.cit., p. 14.

[33] J. M. FAERNA, op. cit., p. 7

myths in particular, was widely spread if not even a must[34]. Ancient Greek references in De Chirico's paintings are persistent, let us think of *Hector and Andromache, The song of love, Furniture and rocks in a room* and *Strange travellers* just to name a few.

> "The pose he strikes in his self-portrait of 1911 is a direct citation of Nietzsche's own portrait photograph. De Chirico saw Nietzsche not only as a guideline but also as a figure of identification [...] With Nietzsche De Chirico shared not only his love of the enigma but also his fascination with the world of classical mythology. Both the Latin quotation beneath the programmatic self-portrait and the eye devoid of a pupil make reference to the blind seer of antiquity. We will encounter the notion of outer blindness again and again in De Chirico's ouvre. Blind to the present, the eye is not fixed on outward form but sees the inner or future shape of things. The Metaphysical artist therefore assumes a prophetic ability to turn

[34] Renato Miracco speaks about "the need felt by 20th century art to go back through past ages and civilizations, attempting to retrieve a primordial gynaeceum, the origin, the matrix, and to develop a monumental representation that will impress itself onto the collective mind and constitute an indelible reference image". R MIRACCO, op. cit., p. 13.

his gaze upon the unfamiliar aspect of things"[35].

Nietzsche is defined by De Chirico as "the most profound of all poets" and the painting *The Delights of the Poet* of 1913 is most likely dedicated to him[36]. Writing to his friend Fritz Gartz, the Master affirms: "I am the only man who has understood Nietzsche, all my works prove it"[37]. What did he mean? In another letter he clarifies:

[35] M. HOLZHEY, op.cit., p. 8.
[36] "The first work to exhibit the typical characteristics of these *Italian squares* with their enigmatic mood is *The Delights of the Poet*: a wide, empty piazza bordered by shadowy arcades leading back into the depths; a high horizon with a locomotive travelling across it; a railway station; a sky of vibrant green; long, slanting shadows; in the square a solitary figure sunk in thought.
The motif of the fountain, already familiar from earlier compositions such as *The enigma of the Hour*, is borrowed from Nietzsche. According to Zarathustra's "Night Song": "Tis night: now do all gushing fountains speak louder. And my soul also is a gushing fountain". *Ibidem*, pag. 24.
[37] De Chirico, Letter to Fritz Gartz, dated "Florence 26 January 1910"; reprinted in Gerd Roos,
 De Chirico e Alberto Savinio. Ricordi e documenti (Monaco, Milano, Firenze, 1906-11)
(Rome: Edizioni Bora, 1999) Appendix I, v, p. 422.

"A new air has now flooded my soul - a new song I've heard - and the whole world now appears to me completely changed - the afternoon Autumn has arrived - stretched shadows, clear air, clear sky - in a word Zarathustra has arrived, did you understand me???"[38].

In the famous chapter *The vision and the enigma* – this title alone could precisely describe the whole art of De Chirico – Zarathustra, talking to the dwarf, he declares:

"See this gateway, dwarf!" I continued. "It has two faces. Two paths come together here; no one has yet walked them to the end. This long lane back: it lasts an eternity. And that long lane outward – that is another eternity.
They contradict each other, these paths; they blatantly offend each other – and here at this gateway is where they come together. The

[38] Quoted in R. DOTTORI, *Dalla poesia di Zarathustra all'estetica metafisica*, in http://www.fondazionedechirico.org/wp-content/uploads/093-116Metafisica7_8.pdf Accessed June, 2019.

name of the gateway is inscribed at the top: 'Moment.'"[39].

The timeless and motionless moment finds its perfect balance both in the nietzschean eternal afternoon[40] and in the afternoon that stretches the uncanny shadows populating De Chirico's squares, filled with schopenhauerian melancholy, mirrors of inner kaleidoscopic experiences. Not a metaphysics of beyond rather a row metaphysics overtly entwined with the empirical facets, embedded in the here and now, made of stillness mightily bewildering.

> "It was this all-important conclusion that De Chirico took from Nietzsche. Pittura Metafisica sought the enigmatic quality of earthly phenomena not in some other dimension, but within the things of this world: "We metaphysicians have sanctified the real", he wrote in 1919. De Chirico, with great penetration, recognized this aspect in

[39] F. NIETZSCHE, *Thus spoke Zarathustra. A book for all and none*, Translated by Adrian del Caro, Chicago: Cambridge University Press 2006, p. 125

[40] "For Zarathustra the "great noontide" meant high point and turning point, the experience of eternity and the stopping of time, a new perception of the world". M. HOLZHEY, op. cit, p. 37.

> Nietzsche, who did not limit himself to the destruction of an idealistic truth but prepared the ground for a new poetics.[41]

De Chirico's aim lies into exercising the eye, like the rest of the senses, in order to realize how metaphysics is rooted in the daily world of experience; only once this goal is reached it is possible to penetrate the enigma of the moment, to have a *vision* of it. To this regard, the Italian painter reminds me of Lev Šestov's "second sight", a rare ability necessary to go beyond the analytical perception of reality, i.e. the lowbrow ordinary perception, in order to glimpse what lies beyond the realm's layers of meanings.

However, this again, refers to an elitist, esoteric matter as the majority of people don't seem able to get that far, as long as they keep their eyes stuck to the traditional arrow of time that hides the moment of the enigma under the linear sequence of past, present and future[42]. Zarathustra's teachings instead, transcending the discontinuity of that

[41] *Ibidem*, p. 15.
[42] As Manlio Sgalambro states: "A philosophical work must be like chamber music for the initiate and it must remain an enigma for the common people". M. SGALAMBRO, *Del pensare breve*, Milano: Adelphi 1991, p. 106.

temporal tryptic, invites the initiate to travel not towards something but into something, something mysterious, as mysterious as "This Moment".

As the master himself points out, the metaphysical aspect of reality can be grasped only in rare seconds, "extraordinary moments which transcend the innocence and distraction of ordinary men"[43], this is because "Psychologically speaking, to discover something mysterious in objects is a symptom of cerebral abnormality related to certain kinds of insanity"[44]. It is an inevitable consequence indeed: if we find the absurd in the very core of things, in their logical connection and in their meaning, then certainly this could appear crazy, at least for common sense. The real madness, as the Master underlines, "doesn't appear to everybody, but it will always be and keep gesticulate and wave behind the matter's screen"[45]. Massimo Carrà was referring at it as the voice of the eternal, as "the grace that in

[43] G. DE CHIRICO, *Sull'arte metafisica*, op. cit., p. 26.
[44] *Ibidem*.
[45] *Ibidem*.

the beginning was flourishing down here: the terrestrial immortality".[46]

Madness attracting De Chirico's concerns, could be also certainly ascribed to his total love for Nietzsche, a philosopher who indeed went crazy. The famous conversation with a horse took place in Turin in Piazza Carlo Alberto, where an equestrian statue of Carlo Alberto stands. The Pictor Optimus depicted that statue in many of his works and it is not difficult to spot an homage to Nietzsche and his madness.

Quite interesting are some affinities between Nietzsche and De Chirico in terms of inspiration and disease. First of all Nietzsche, as well as De Chirico, suffered from migraines, without aura[47] though.

Elisabeth Forster-Nietzsche writes:

> "As I had already saidy, the illness that embittered my brother's whole life was a migraine. The days of headaches and nausea followed one another, in the best periods, every three, four weeks, but in the worst periods they haunted him almost every week... Sometimes I thought that these

[46] M. CARRA', *Metafisica*, Milano: Gabriele Mazzotta Editore 1968, p. 242.

[47] In the next chapter the concept of "aura" will be analysed deeeply.

attacks were a cruel trick of nature to keep him away from his work, since in those days he could do nothing at all"[48].

And this is the first affinity, the second relies on the concept of disease as a real source of inspiration, let us listen to Nietzsche himself:

"Once, during the continuous torture my brain gave me for three days accompanied by a painful vomit of mucus, I had an exceptional dialectic lucidity and I was able to think in cold blood and in every particular thing for which, in better health, I do not demonstrate a sufficient ability, a sufficient coldness"[49].
Of
Therefore, both Nietzsche and De Chirico conferred high value to their diseases in relation to the concept of creativity itself. As we will shortly see (in the next chapter), not only important rather *determinant* is the value De Chirico always bestowed to his set of diseases, let us mention the day in Piazza Santa Croce, when he had the intuition of *Enigma d'un pomeriggio d'autunno* (1910) and

[48] FÖRSTER NIETZSCHE E. *Die Krankheit Friedrichs Nietzsche.* Die Zukunft 1900; 30: 9-27
[49] *Ibidem*, p. 14-15.

actually, when Metaphysical Art was born. Here's his own words about it:

> «On a clear autumn afternoon I was sitting on a bench in the middle of Piazza Santa Croce in Florence. It certainly wasn't the first time I had seen this square. I had just come out of a long and painful intestinal disease and I was in a state of almost morbid sensitivity. The whole nature, up to the marble of the buildings and fountains, seemed to me convalescing. In the middle of the square stood a statue that represented Dante dressed in a long cloak (…). The statue was in white marble; but time had given it a very pleasant gray tint. The autumn sun, warm and without love, illuminated the statue and the facade of the temple. Then I had a strange impression of seeing everything for the first time. And the composition of my painting came to mind; and every time I looked at it I saw this moment again: however, the moment for me is an enigma, because it is inexplicable. And I also like to call enigma the work inspired by it»[50].

[50] G. DE CHIRICO, *Scritti/1* (1911- 1945). *Romanzi e scritti critici e teorici*, a cura di A. Cortellessa, Milano: Bompiani 2008, pp. 649-652.

Noteworthy De Chirico sees a disease in the surrounding reality as well ("the whole nature, up to the marble of the buildings and fountains, seemed to me convalescing"), not only in himself. This lets us understand how sizable in the dechirichian *Weltanschauung* is the marriage of art and disease.

Ultimately, we need to consider how mesmerizing was the theory of the eternal return for De Chirico. The painter was "hypnotized" by this concept because of two different reasons, the first refers to his migraine problems while the second concerns an extremely fascinating belief.

De Chirico suffered from a very peculiar disease called "migraine aura" which will be analysed in the next chapter, one of this disease's symptoms is *déja-vù*. In his writings the Pictor Optimus, repeatedly speaks about *déja-vù* sensations, at times in association with other migraine symptoms. All things considered, it may be pertinent to propose, as Nicola and Podoll also do[51], a link between these symptoms and the nietzchean concept. In other words it could have been precisely

[51] See: U. NICOLA, K. PODOLL, *L'enigma di Giorgio de Chirico. La nascita della pittura metafisica dallo spirito dell'emicrania.*

these migraine experiences that aroused his interest in this philosophical doctrine.

The second reason, from a critical point of view, is undoubtedly very exciting: De Chirico seems to have truly believed in being the reincarnation of Nietzsche.

As discovered by Schmied[52], this identification is evident from the eloquent title of a work of 1914: *Natura morta, Torino 1888*. Quite significantly, that year, 1888, was marked both by the birth of the painter in Volos, Greece and by the psychotic crisis of the philosopher in Turin.

According to Baldacci: "De Chirico, as also confirmed by Savinio, believed that Nietzsche's wandering soul had abandoned the philosopher's body to enter his"[53].

Schmied suggests that: "Yes, the identification went so far that it sometimes produced the same symptoms as Nietzsche's disease"[54].

[52] W. SCHMIED, *De Chirico und sein Schatten. Metaphysische und surrealistische Tendenzen in der Kunst des 20. Jahrhunderts*. München: Prestel 1980; pp. 57-60.

[53] P. BALDACCI, *Giorgio de Chirico. The metaphysical period 1888-1919*. Boston-New York-Toronto-London: Little Brown and Co. 1997.

[54] W. SCHMIED, *Die metaphysische Kunst des Giorgio de Chirico vor dem Hintergrund der deutschen Philosophie: Schopenhauer, Nietzsche, Weininger*. In: W. RUBIN, W.

Yet this is another aspect that makes this character, a great character, from an artistic, philosophical and psychological point of view.

As is now quite clear, De Chirico's specific perception of reality was, albeit partially, influenced by his health disorders, one in particular: the migraine aura and its consequent hallucinations.

SCHMIED, J. CLAIR, *Giorgio de Chirico der Metaphysiker*, München: Prestel 1982; pp. 89-107.

Out of the shadow of the abstract man, who thinks for the pleasure of thinking, emerges the organic man, who thinks because of a vital imbalance, and who is beyond science and art.

Emil Cioran

Migraine aura: a source of revelation.

As is now quite clear, De Chirico's specific perception of reality was, albeit partially, influenced by his health disorders, one in particular: the migraine aura and its consequent hallucinations. De Chirico, who was never given a diagnosis, literally did not know that he suffered from it but experienced the unusual symptoms: the hallucinations[55].

[55] De Chirico's migraine aura disease was deeply studied by the philosopher Ubaldo Nicola and the neurologist and psychiatrist Klaus Podoll. According to them Migraine Aura «synthesizes a very diverse set of events. Very common is the appearance of optical and luminous phenomena, of lights or zigzag lines, real holes in the perceptual field (scotomas) or even visual hallucinations. Patients often report seeing architectural forms similar to the walls of a fortified city, so much so that one of the most typical hallucinations is called the "specter of fortification"». U. NICOLA - K. PODOLL, *L'aura di De Chirico. Aura emicranica e pittura metafisica*, Milano, Mimesis: 2003, pag. 31.
As the two scholars assert, a typical characteristic of these patients is the reticence, i.e. they tend not to talk about it for fear of being mistaken for madmen, however, De Chirico didn't fall into this perspective as we will shortly see.

The total ignorance about the illness from which he suffered for his whole life, is reflected in his writings, from the *Memoirs*[56] to *Ebdomero*[57], where not only his total unconsciousness is evident, but also the consequences that it entailed, especially on the level of personality, altered by an ego magnified by the fact of "seeing what others did not see".

In other words, De Chirico, in the wake of these hallucinations (mistaken for visions and revelations) and in the wake of the love for Nietzsche, felt himself a sort of superman, a superior being, "the One".

In his famous autobiographical work *Ebdomero*, De Chirico repeatedly speaks of hallucinations that began in childhood: «During the diurnal hallucinations of my dark childhood I saw the tragedy of Golgotha above a city boulevard shaded by two rows of pepper trees»[58]. He remembered how many times, in his youth, appearances had deceived him, for example «that time when I was a

[56] G. DE CHIRICO, *Memorie*, Milano, Bompiani: 2016.
[57] G. DE CHIRICO, *Ebdòmero*, Milano, Abscondita: 2016.
[58] Quoted in: M. FAGIOLO DELL'ARCO, *Il meccanismo del pensiero. Critica, polemica, autobiografia 1911 – 1943*, Torino: Einaudi 1985, pag. 50.

child and I couldn't sleep because a huge mask appeared on the ceiling of my room»[59].

One of the most frequent visions for those in the grip of a hallucination produced by migraine aura, are zigzag shapes (abundantly present in works such as *Il rimorso di Oreste* and *Il ritorno al castello*, both from 1969) and geometric figures, the latter plentiful in De Chirico's work. We could say that they qualify as "revelations" as they reveal another face of reality, a further, metaphysical face indeed; this is why, that of De Chirico can be defined as a "revealed painting". As he himself states: «The painter, who had the true revelation, traces the image of those strange things, inconceivable to our logic and which are not the fruits of imagination, but the faithful image of a different world from ours, seen by an elected man, a world no human fantasy could manage to create»[60]. The artist therefore does not invent, he *sees* and he does so by dint of the aura, understood as a revealing organ *tout court*.

[59] G. DE CHIRICO, *Ebdòmero*, Milano, Abscondita: 2016, pag. 57.
[60] G. DE CHIRICO, *Discorso sulla materia pittorica*, in G. de Chirico - I. Far, *Commedia dell'arte moderna*, a cura di J. de Sanna, Abscondita, Milano, 2002, pp. 146-173, p. 167.

As a matter of fact, his pathology was a source of both stress and inspiration. The aura can arise suddenly without an apparent cause, it is not painful and in no way affects the intellectual abilities, the subject remains totally alert and conscious throughout the considerable period of action of the aura, about twenty minutes. One can therefore observe and possibly draw the phenomena of visual content.

Another prominent feature of the aura is the unpredictability that makes one live in a perennial state of alert since the aura itself is always lurking, about to explode. «This sense of imminence is precisely the fundamental poetic dimension of metaphysics. The temporal state of the Italian Squares is that of waiting; there is in them something similar to a prodromal state. One feels that an unpleasant event is about to happen, something inevitable and inexplicable together»[61].

[61] U. NICOLA – K. PODOLL, op. cit. p. 120. De Chirico delves into the question: «The work of metaphysical art is, as for the serene aspect; however, it gives the feeling that something new must happen in that same serenity and that other signs, in addition to those already evident, must take over the square of the canvas. This is the revealing symptom of an "inhabited depth"». G.

Jean Cocteau in his essay *Le mystere laic* states that «when we stop looking at a town of De Chirico, monsier X ... turns the corner of the street, crosses it, pulls the key out of the pocket and enters the house»[62].

Let us consider the words of the Master himself concerning one of his innumerable revelations:

> «On a brilliant winter afternoon, I was in the courtyard of the Versailles palace. Everything looked at me with a strange and questioning look. I saw that every corner of the building, every column, every window had an enigmatic soul. I saw stone heroes around me, motionless under the clear sky, under the cold rays of a shining winter sun without love, like a deep song. A bird sang in a cage hanging from a window. Then I understood all the mystery that leads man to create certain things. And the creations seemed to me even more mysterious than the creators: it is useless to try to explain certain things scientifically, nothing is achieved. The palace was as I had imagined it. I had a presentiment that this should be

DE CHIRICO, *On metaphysical art*, in M. FAGIOLO DELL'ARCO, op.cit. , pag. 88

[62] J. COCTEAU, *Giorgio De Chirico. Il mistero laico*, a cura di Alberto Boatto, Milano: Abscondita 2015, p. 33.

so, that it could not be otherwise. An invisible bond links everything, and at that moment it seemed to me that I had already seen that building, or that that building had already existed once, somewhere; and the round windows; why are they a puzzle? Why can they only be French? What else could they be? Don't they have a strange expression?... Then more than ever I felt that everything was happening there fatally, but for no purpose and without reason»[63].

In this long quotation there are several typical elements of the Dechirichian prose and experiences, first of all a well-known migraine symptom which is the mental state of derealisation, i.e. the feeling that the world appears unreal or at least different from the usual, we then obviously have the inevitable sense of mystery that pervades all things linked invisibly until a Nietzschean tone is reached on the happening of things in the absence of reason and then, almost inevitable, the *déjà vu*.

De Chirico, moreover, suffered not only from *déjà vu* but also from *jamais vu*, that is, to have the impression that the scene one is witnessing never happened. He suffered from

[63] G. DE CHIRICO, *Manoscritti parigini*, in M. FAGIOLO DELL'ARCO, op.cit., pag. 19-20.

both symptoms, because they occasionally appear as migraine symptoms. De Chirico obviously interpreted them as revelations.

However, it must be considered that *déjà vu* for migraineurs are quite specific. We all may have had at least once in our lives an experience of *déjà vu* and we know very well how much it lasts, a split second or a little bit more, for the sick migraineurs instead it occupies a much longer time lapse. We can only try to imagine what it means to experience an event of this type that lasts, for example, ten minutes. Obvious then is the profound sense of disorientation that De Chirico lives as "revelation": the perception of a reality that is indeed different, seen and really lived in a different way, metaphysically to be precise. To this regard, Nicola and Podoll point out: «He considered his power of access to this particular state of mind as the very essence of his artistic creativity, at least in the metaphysical period»[64].

On the whole, the perception that the Master had of himself and in general, his personality, are deeply affected by the migraine aura.

De Chirico then, already profoundly influenced by Nietzsche, by both his figure

[64] U. NICOLA – K. PODOLL, op. cit. p. 40.

and his philosophy, tended to attribute himself some kind of "super powers". However, the "superman" he somehow felt to be, was *not* meant *only* in the Nietzschean sense, but also in an esoteric sense *tout court*. De Chirico was used to having divinatory or premonitory experiences (or at least they seemed to be as such to him), the most emblematic and famous case is the *Portrait of Apollinaire* of 1914 where De Chirico painted him with a Dante profile on whose left temple, a circle similar to a shooting target was depicted. Interestingly, Apollinaire two years later at war was wounded exactly at that point.

Moreover, what to think of the fact that «he claimed to have revelations, premonitory and clairvoyant dreams, to see inside objects as if he had an X-ray view? Or finally when he attributed himself very special, if not even paranormal, powers, such as becoming, but only sometimes, phosphorescent?»[65]

Let us listen to the Master himself, in this regard:

«For example, I am phosphorescent. I'm not kidding ... I see my hand in the dark. Moreover, the more time passes, the more I

[65] *Ibidem*.

realise that I am an extraordinary man»⁶⁶. His words leave no shadow of a doubt on the way he perceived himself and on the powers he thought to possess, powers among the most disparate. Breton, for example, cites his ability to see ghosts:

> «Ghosts... However reticent this point may be, De Chirico admits he has not forgotten them. In a sudden moment of confidence that now he must regret, he even gave me the name of two of them: Napoleon III and Cavour and he made me understand that he had had an intense acquaintance with them... I have no idea how many weird characters of this nature have populated the long hours of De Chirico's loneliness, but even if one should not attribute to all of them the same importance, they must have been legions»⁶⁷.

⁶⁶ G. DE CHIRICO, *Memorie*, op. cit. p. 27
⁶⁷ A. BRETON, *Le surréalisme et la peinture*, Paris: Gallimard 1928, pp. 35-6.
De Chirico speaks about ghosts in another circumstances as well, for example in the 1938 essay entitled *I was in New York*, where he describes his arrival in the city: «Once this frontier is overcome, you are on the other side; whether it's better or worse I don't know; what I know is that you are in another world; in a subtle way everything has changed; one feels a bit like one has died; of course one always

In yet another testimony Breton suggests how his faculties can be caused by feelings of *déjà-vu*:

> «Both Louis Aragon and I remember it well one evening when we were sitting with De Chirico in a cafe in Piazza Pigalle, and a boy passed from table to table selling flowers. De Chirico had his back to the door and could not have seen him enter, but Aragon had been struck by the strange appearance of the newcomer and wondered aloud if he was not by chance a ghost. Instead of turning, De Chirico pulled out a small pocket mirror and after studying the young man carefully for a few minutes, replied that he was indeed a ghost. He certainly seemed exceptionally knowledgeable in the recognition of ghosts with a human aspect, he even assured us that his merchant Paul Guillame, resembles

moves, one eats, one smokes, one walks, one converses, one reads, one does everything as before, but in all this there is a little activity of the ghost... ». G. DE CHIRICO, *Sono stato a New York*, Fondazione Giorgio De Chirico, 1938. http://www.fondazionedechirico.org/wp-content/uploads/681-682Metafisica7_8.pdf

[67] Quoted in U. NICOLA – K. PODOLL, op. cit. pag. 42.

in every respect the description given to him by imagination»[68].

Taking everything into account, from the painter's perspective, the world can be perceived according to two specific and antithetical aspects, «a usual one, which we almost always see and which men generally see and the other, the spectral or metaphysical, which can only be seen by rare individuals in moments of clairvoyance and metaphysical abstraction»[69]. He obviously falls into this last and restricted category and loves to remark it repeatedly in his writings and interviews. It should be noted that while many migraine aura patients are reticent in revealing their experiences for fear of being taken for a fool, De Chirico, according to an opposite logic, raises them to superior qualities that distinguish him from the mass. Ubaldo and Podoll delve into the question, the quotation is rather long but deserves to be reported in full as it is extremely clarifying:

> «It is entirely understandable that in many situations of everyday life [...] De Chirico wanted to hide his diversity. But for most of

[68] *Ibidem.*
[69] G. DE CHIRICO, *Sull'arte metafisica*, op. cit. pp-85-6.

the times, he was not reticent. Quite the reverse. The strategy with which he faced the auratic symptoms was not concealment but exhibition. If today it is possible to make a diagnosis it is because the Master had the courage to tell the bizarre phenomena that happened to him at the cost of being taken for a simulator or an eternal child who likes to joke too much. Certainly he played on ambiguity, presenting his stories as something in between biography and fantasy novels, knowing that this would not have been believed. And what could the reader think, just to give an example, of his repeated assurances that one day he had really seen the critic Longhi plunging into the pavement and reappearing at the end of the square? Either not believing him, assuming that "pieces" like this were surrealist eccentricities, or really signaling him "to the authorities of the country". Nobody believed him, of course, and this mechanism of ambiguity allowed the Master to keep telling the truth»[70].

And the truth was obviously related to the hallucinated world he experienced, then painted, he was actually proud of an

[70] U. NICOLA – K. PODOLL, op. cit. pp. 92-93.

experience that was neither mystical nor dreamy, nor religious nor surrealist, it was simply, silently, spectrally metaphysical.

There are not two separate worlds, two different realities, a normal world and a paranormal world… but only one world, that you can "look at" or "see".

Carlos Castanedda

Conclusion

About his painting *The Nostalgia of the Infinite*, the Master stated:

> "Shadows cast their geometric enigma across the piazzas. Above the walls rise nonsensical towers topped with small, colourful flags. Everywhere infinity, everywhere mystery. The depth of the celestial vault makes one feel dizzy to look at it. One shudders, one feels pulled into the abyss".

The same abyss that divided him from most of the art surrounding him at his time.
De Chirico found his juxtaposition between physics and metaphysics, between Futurism and Freud, between the racket of the war and the silence at the Hospital of Ferrara, between the noise and the speed of airplanes and the peace of the empty Italian squares, between revelations and hallucinations, between the attention to the subconscious and the analysis of the outward - the extremely enigmatic surface, the most mysterious aspect of reality itself.
De Chirico's figure dwelled amid those categories of opposites and there felt at ease

after all, as he, himself, was a case in point in '900's art, the main representative of a movement which was born and died with him, worthy to be studied now and forever.

Chiarire un mistero è indelicato verso il mistero stesso.

Alberto Savinio

www.luciogiuliodori.net

www. rudn.academia.edu/LucioGiuliodori

www.ingramcontent.com/pod-product-compliance
Lightning Source LLC
Chambersburg PA
CBHW022125170526
45157CB00004B/1762